Patterning Techniques

A pattern is a repetition of shapes and lines that can be simple or complex depending on your preference and the space you want to fill. Even complicated patterns start out very simple with either a line or a shape.

Repeating shapes (floating)

Shapes and lines are the basic building blocks of patterns. Here are some example shapes that we can easily turn into patterns:

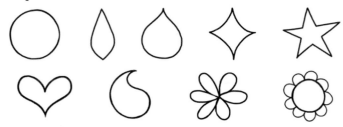

Before we turn these shapes into patterns, let's spruce them up a bit by outlining, double-stroking (going over a line more than once to make it thicker), and adding shapes to the inside and outside.

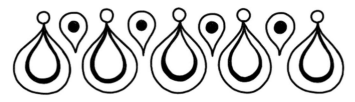

To create a pattern from these embellished shapes, all you have to do is repeat them, as shown below. You can also add small shapes in between the embellished shapes, as shown.

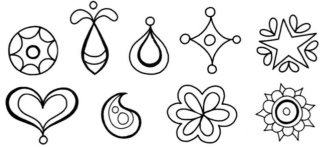

These are called "floating" patterns because they are not attached to a line (like the ones described in the next example). These floating patterns can be used to fill space anywhere and can be made big or small, short or long, to suit your needs.

Tip

Draw your patterns in pencil first, and then go over them with black or color. Or draw them with black ink and color them afterward. Or draw them in color right from the start. Experiment with all three ways and see which works best for you!

Tip

If you add shapes and patterns to these coloring pages using pens or markers, make sure the ink is completely dry before you color on top of them; otherwise, the ink may smear.

Repeating shapes (attached to a line)

Start with a line, and then draw simple repeating shapes along the line. Next, embellish each shape by outlining, double-stroking, and adding shapes to the inside and outside. Check out the example below.

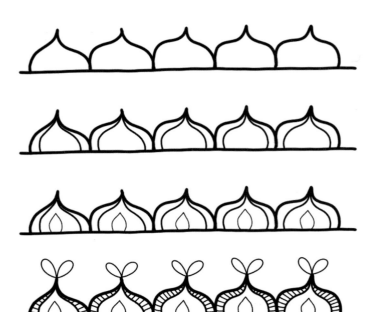

You can also draw shapes in between a pair of lines, like this:

Embellishing a decorative line

You can also create patterns by starting off with a simple decorative line, such as a loopy line or a wavy line, and then adding more details. Here are some examples of decorative lines:

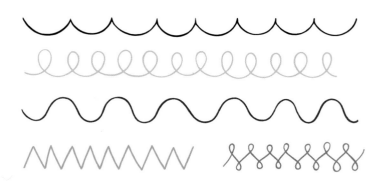

Next, embellish the line by outlining, double-stroking, and adding shapes above and below the line as shown here:

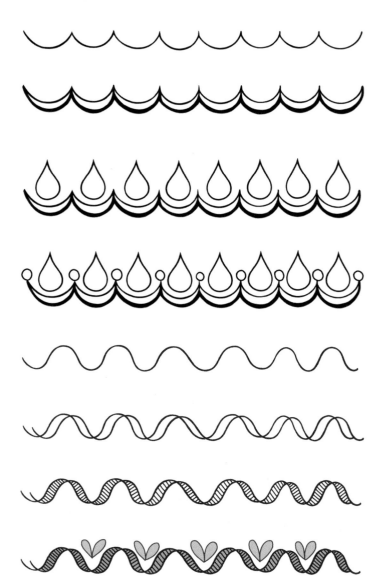

Color repetition

Patterns can also be made by repeating sets of colors. Create dynamic effects by alternating the colors of the shapes in a pattern so that the colors themselves form a pattern.

Tip

Patterns don't have to follow a straight line—they can curve, zigzag, loop, or go in any direction you want! You can draw patterns on curved lines, with the shapes following the flow of the line above or below.

These types of patterns look great when attached to the inner or outer edge of a drawing, such as the inside of a flower petal or butterfly wing.

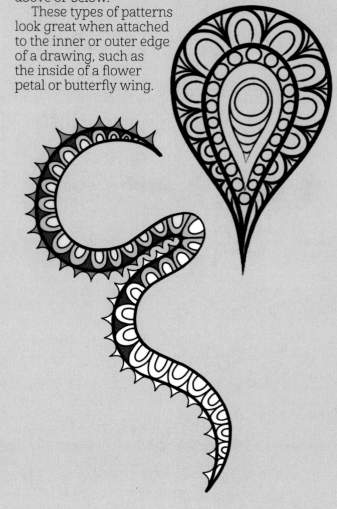

Coloring Techniques & Media

My favorite way to color is to combine a variety of media so I can benefit from the best that each has to offer. When experimenting with new combinations of media, I strongly recommend testing first by layering the colors and media on scrap paper to find out what works and what doesn't. It's a good idea to do all your testing in a sketchbook and label the colors/brands you used for future reference.

Markers & colored pencils
Smooth out areas colored with marker by going over them with colored pencils. Start by coloring lightly, and then apply more pressure if needed.

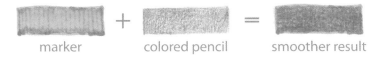

Test your colors on scrap paper first to make sure they match. You don't have to match the colors if you don't want to, though. See the cool effects you can achieve by layering a different color on top of the marker below.

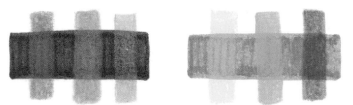

Markers (horizontal) overlapped with colored pencils (vertical).

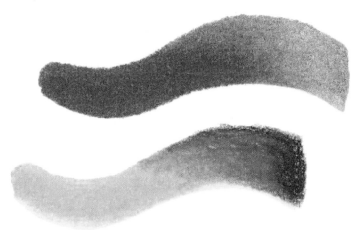

Purple marker overlapped with white and light blue colored pencils. Yellow marker overlapped with orange and red colored pencils.

Markers & gel pens
Markers and gel pens go hand in hand, because markers can fill large spaces quickly, while gel pens have fine points for adding fun details.

White gel pens are especially fun for drawing over dark colors, while glittery gel pens are great for adding sparkly accents.

Shading

Shading is a great way to add depth and sophistication to a drawing. Even layering just one color on top of another color can be enough to indicate shading. And of course, you can combine different media to create shading.

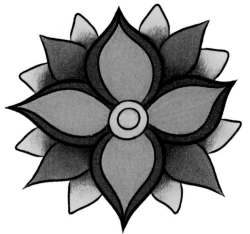

Colored with markers; shading added to the inner corners of each petal with colored pencils to create a sense of overlapping.

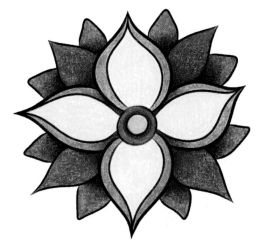

Colored and shaded with colored pencils.

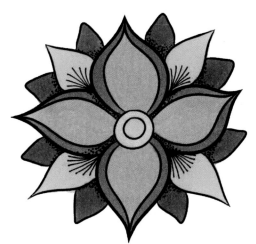

Lines and dots were added with black ink to indicate shading and then colored over with markers.

Color Theory

Check out this nifty color wheel. Each color is labeled with a P (primary), S (secondary), or T (tertiary). The **primary colors** are red, yellow, and blue. They are "primary" because they can't be created by mixing other colors. Mixing primary colors creates the **secondary colors** orange, green, and purple (violet). Mixing a primary color and a secondary color together creates the **tertiary colors** yellow-orange, yellow-green, blue-green, blue-purple, red-purple, and red-orange.

Working toward the center of the six large petals, you'll see three rows of lighter colors, called tints. A **tint** is a color plus white. Moving in from the tints, you'll see three rows of darker colors, called shades. A **shade** is a color plus black.

The colors on the top half of the color wheel are considered **warm** colors (red, yellow, orange), and the colors on the bottom half are called **cool** (green, blue, purple).

Colors opposite one another on the color wheel are called **complementary**, and colors that are next to each other are called **analogous**.

Look at the examples and note how each color combo affects the overall appearance and "feel" of the butterfly. For more inspiration, check out the colored examples on the following pages. Refer to the swatches at the bottom of the page to see the colors selected for each piece.

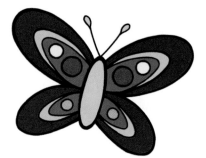
Warm colors

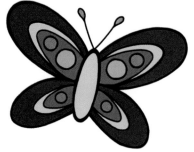
Cool colors

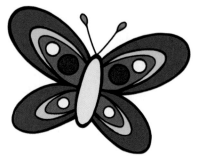
Warm colors with cool accents

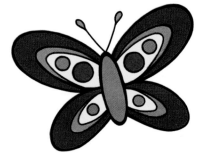
Cool colors with warm accents

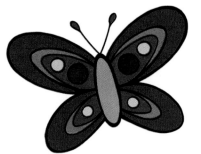
Tints and shades of red

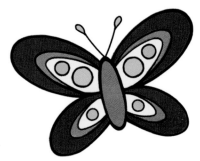
Tints and shades of blue

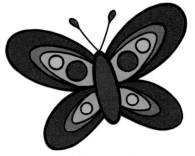
Analogous colors

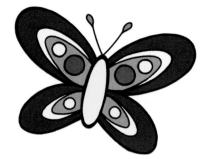
Complementary colors

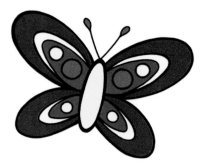
Split complementary colors

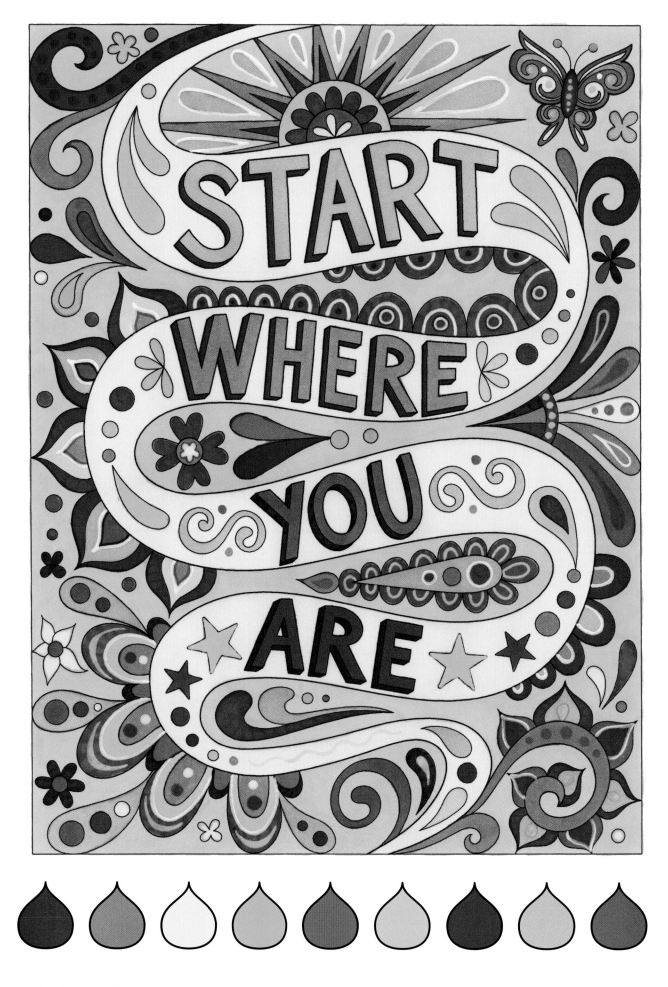

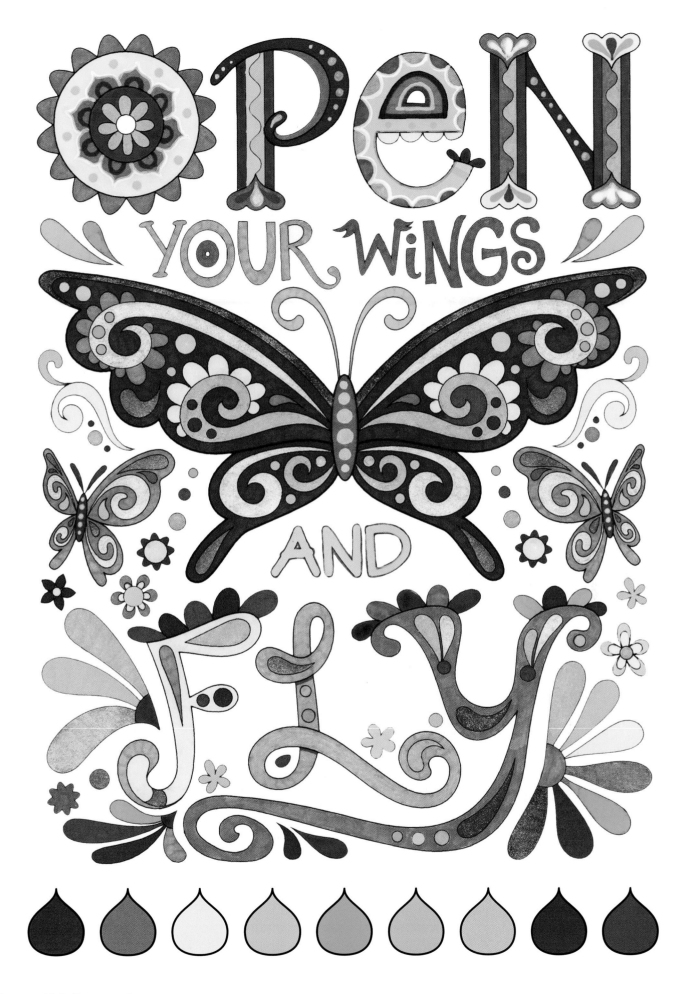

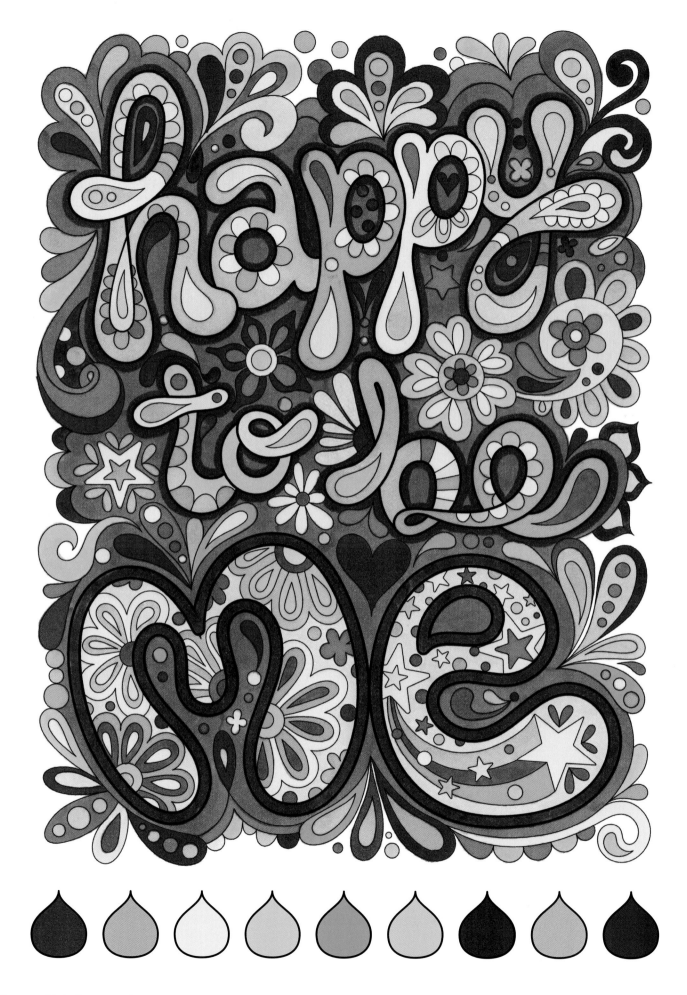

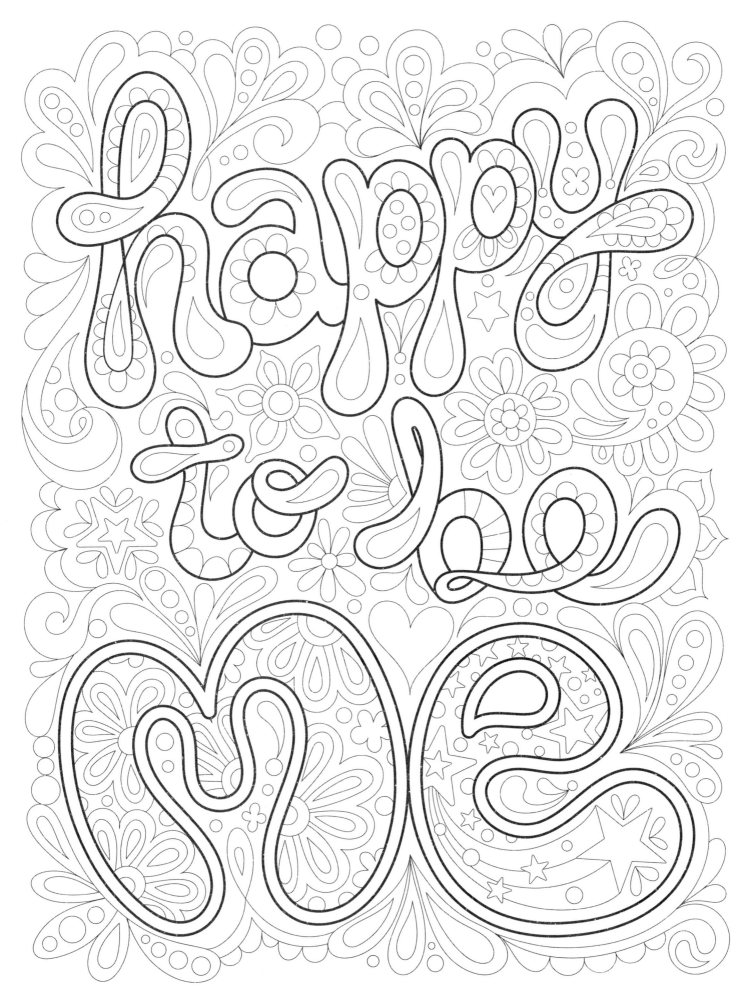

It's not your job to like me—it's mine.

—Byron Katie

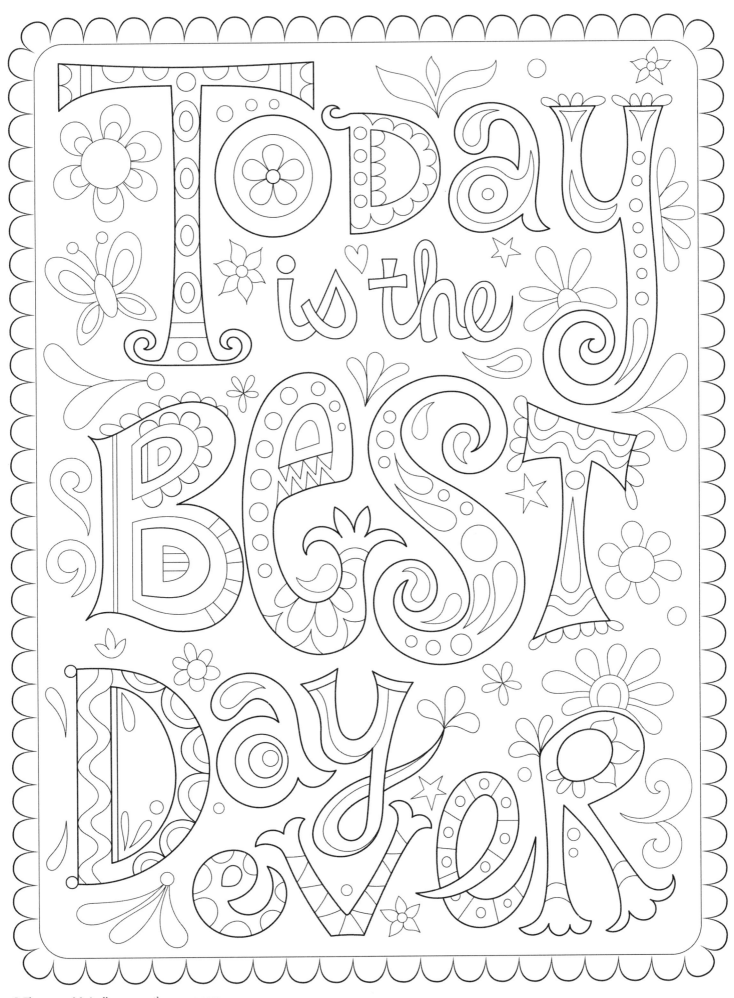

Life does not have to be perfect to be wonderful.

—Unknown

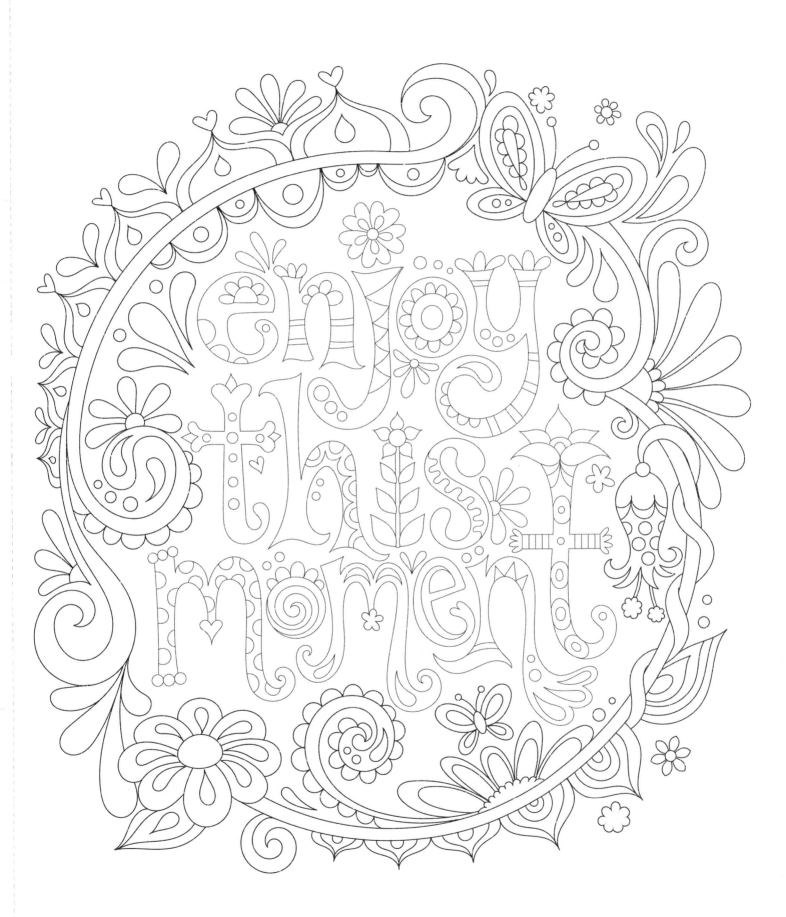

And now go, and make interesting mistakes,
make amazing mistakes, make glorious
and fantastic mistakes.

—Neil Gaiman

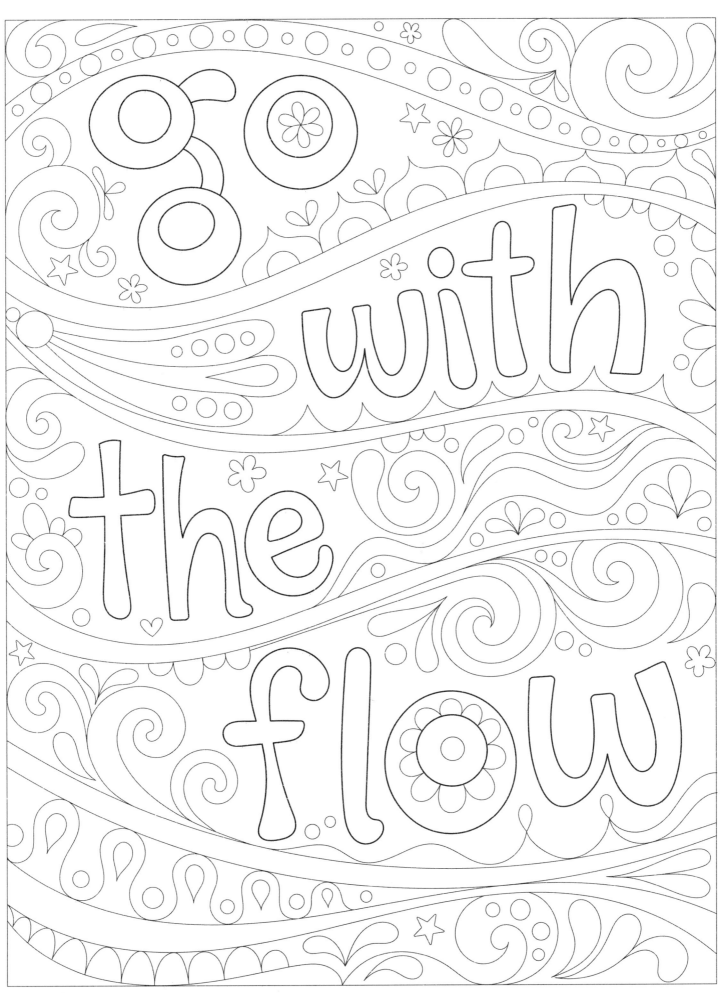

Everything you can imagine is real.

—Unknown

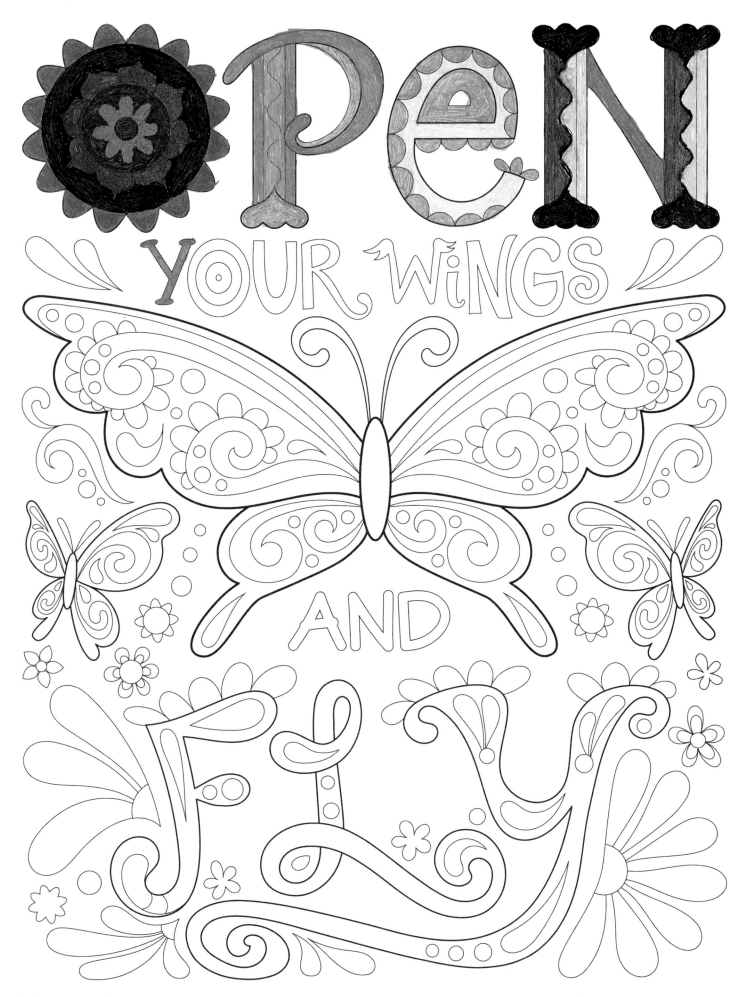

OPEN YOUR WINGS AND FLY

The question isn't who is going to let me;
it's who is going to stop me.

—Ayn Rand

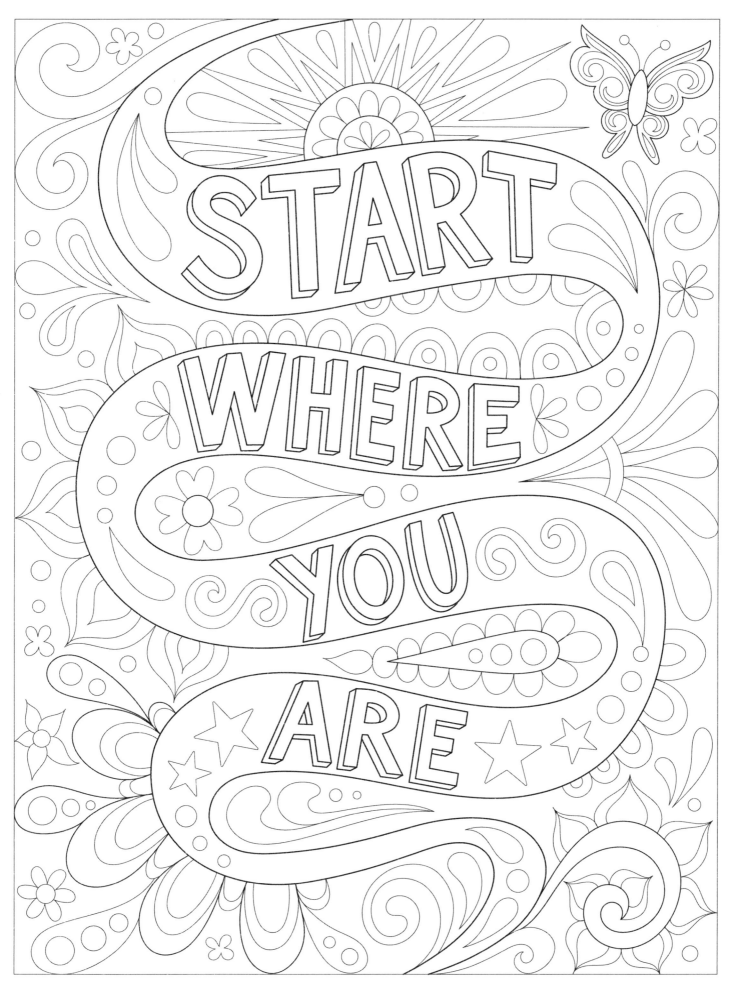

You are confined only by the walls
you build yourself.

—Unknown

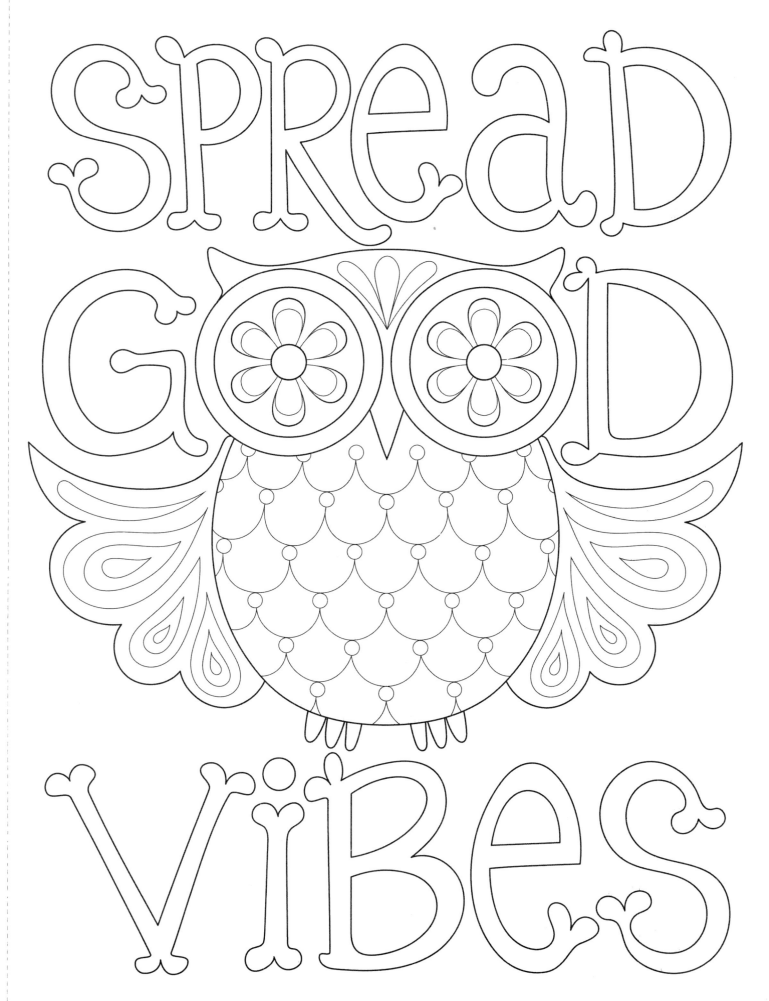

No act of kindness, no matter how small,
is ever wasted.

—"The Lion and the Mouse," *Aesop's Fables*

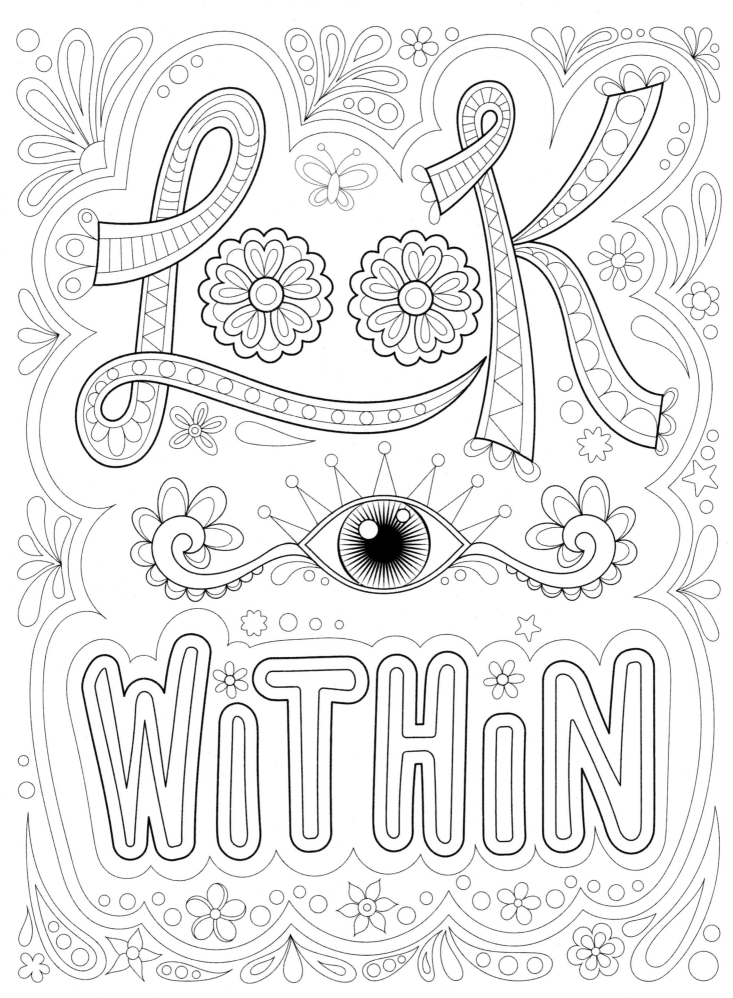

Wheresoever you go, go with all your heart.

—Confucius

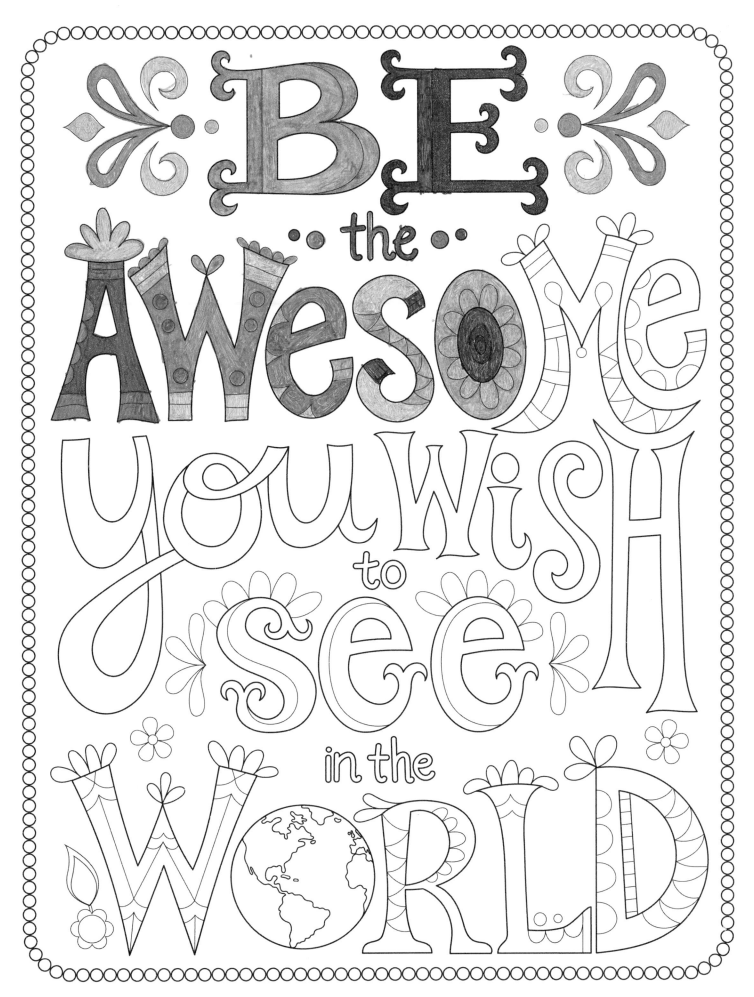

BE the AWESOME you wish to see in the WORLD

Then give to the world the best that you have,
And the best will come back to you.

—Madeline Bridges, *Life's Mirror*

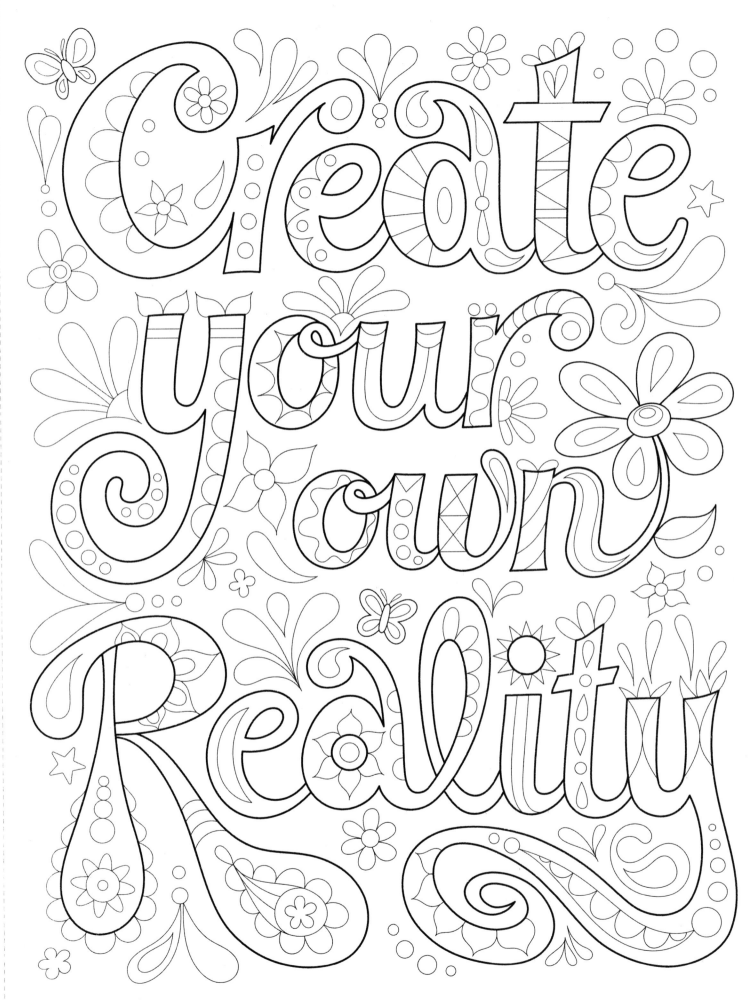

The most effective way to do it, is to do it.

—Amelia Earhart

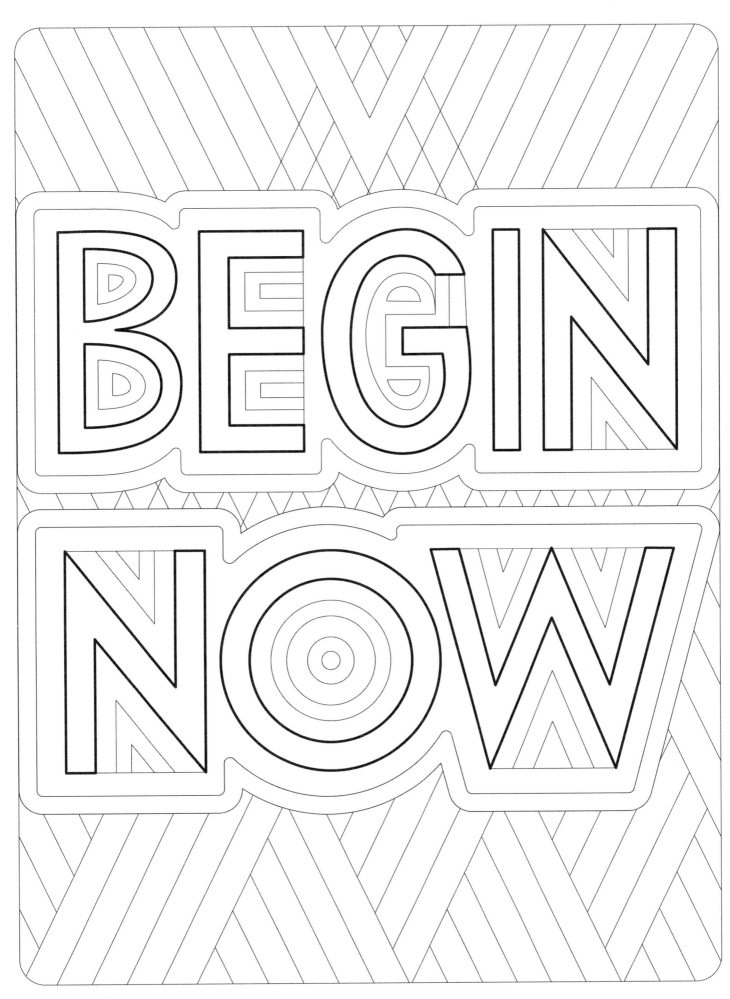

The way to get started
is to quit talking and begin doing.

—Walt Disney

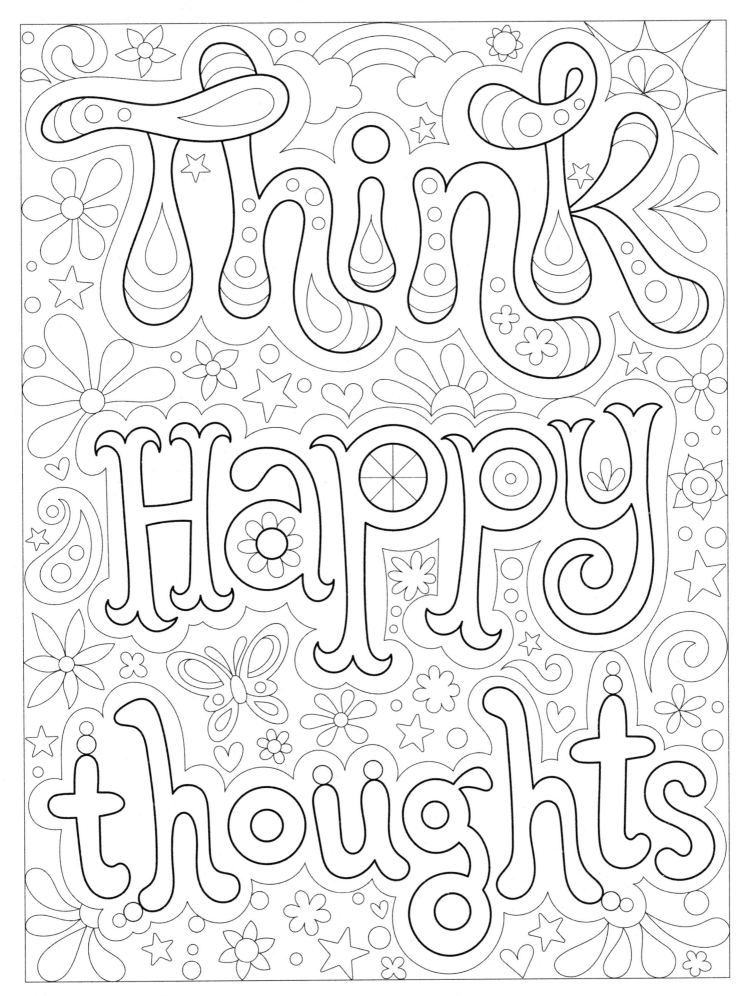

Life itself is the most wonderful fairytale.

—Hans Christian Andersen

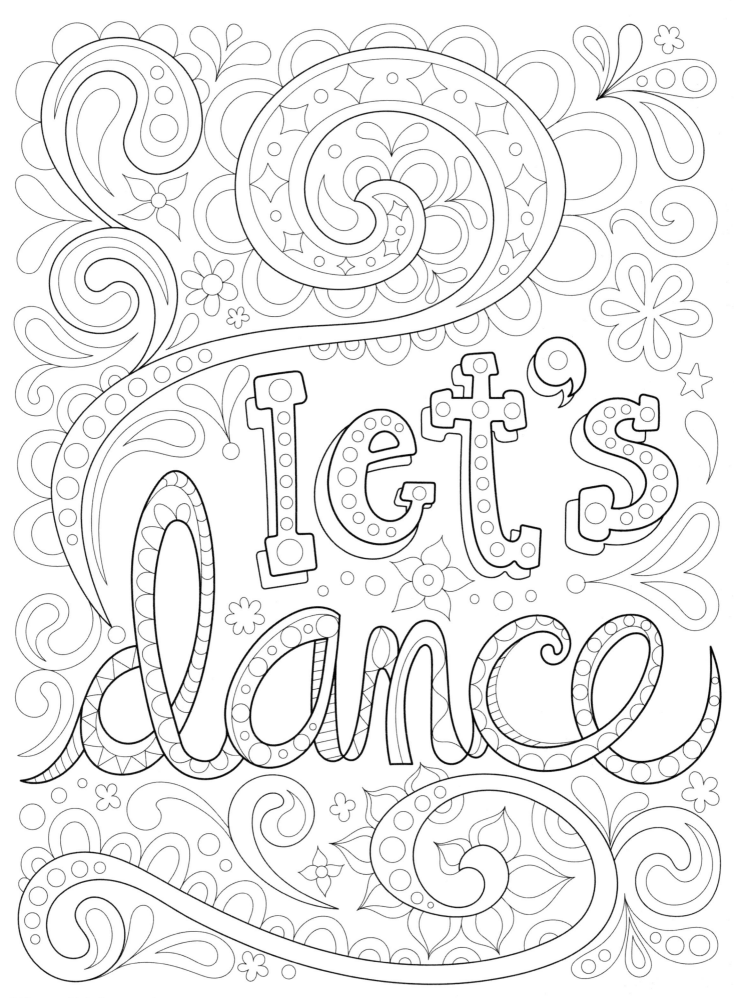

Tonight
We are young
So let's set the world on fire
We can burn brighter than the sun

—Fun., *We Are Young*

I, I did it all
I owned every second that this world could give
I saw so many places, the things that I did
With every broken bone, I swear I lived

—One Republic, *I Lived*

My mission in life is not merely to survive,
but to thrive; and to do so with some passion,
some compassion, some humor, and some style.

—Maya Angelou

This is what my soul is telling me:
Be peaceful and love everyone.

—Malala Yousafzai

Never dull your shine for somebody else.

—Tyra Banks

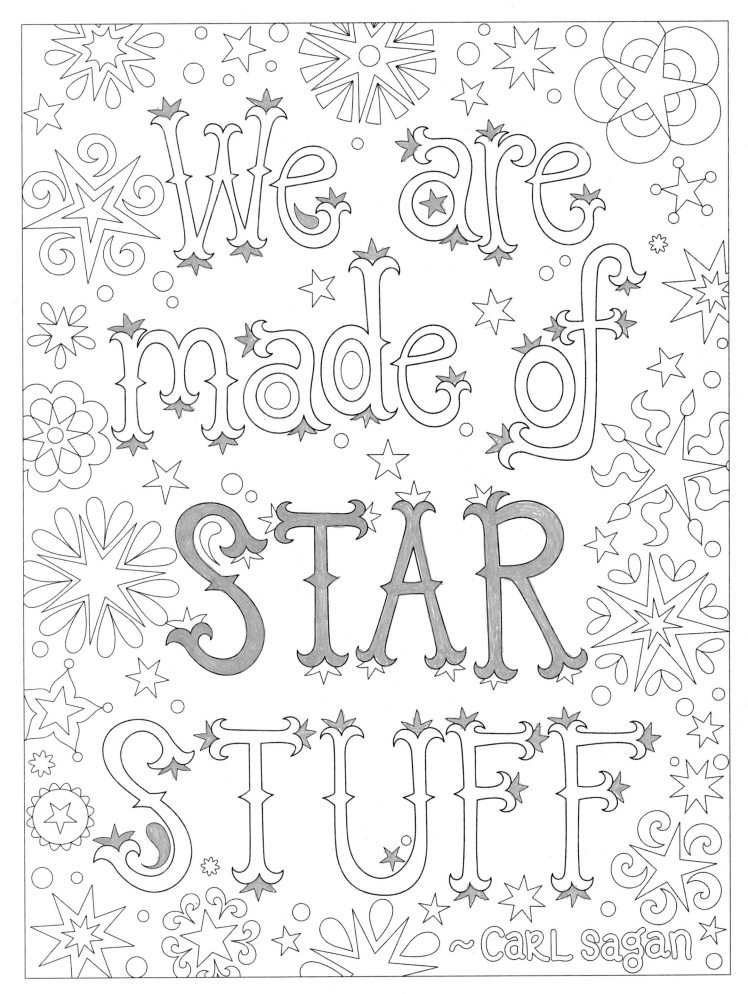

I got the eye of the tiger, a fighter, dancing through the fire
'Cause I am a champion and you're gonna hear me roar

—Katy Perry, *Roar*

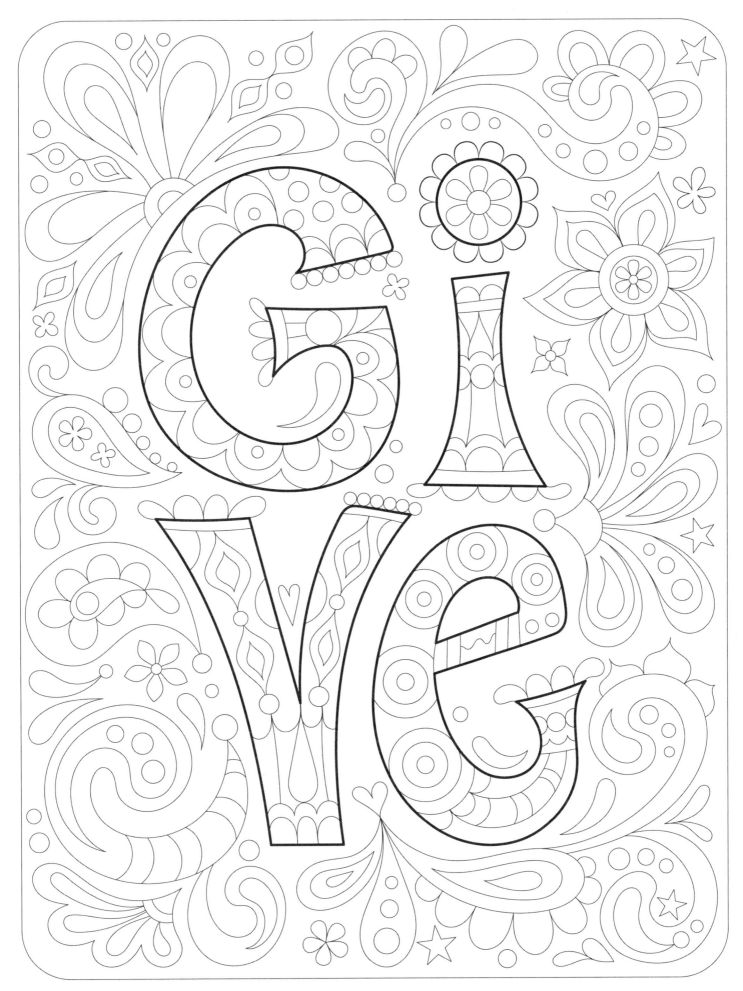

Happiness doesn't result from what we get,
but from what we give.

—Unknown

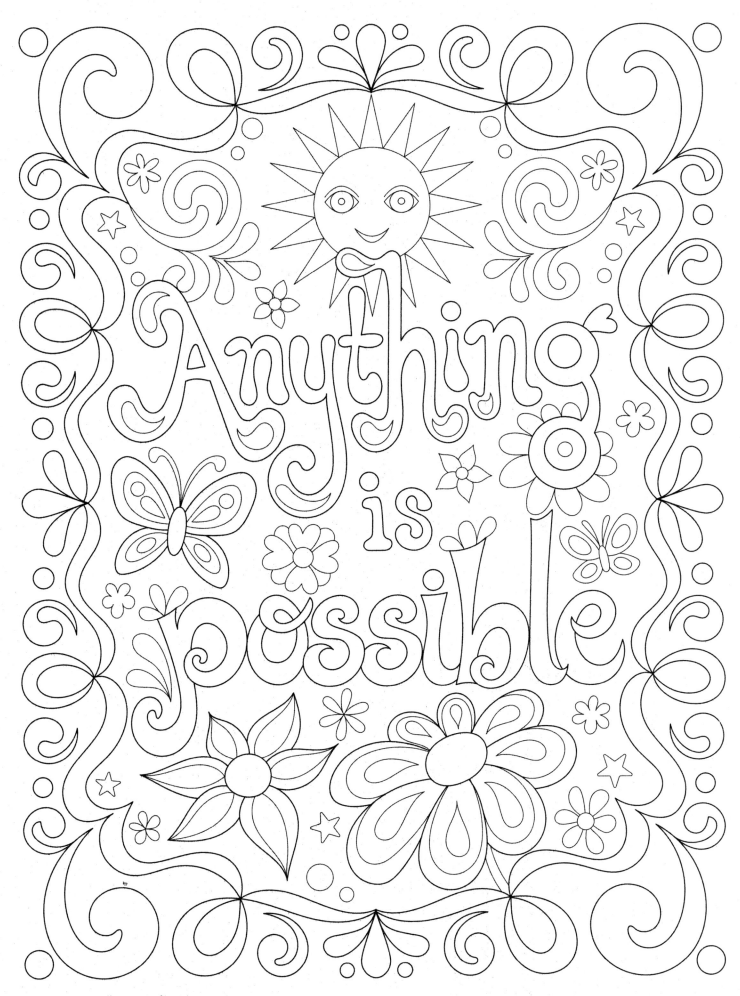

Instead of thinking outside the box, get rid of the box.

—Deepak Chopra

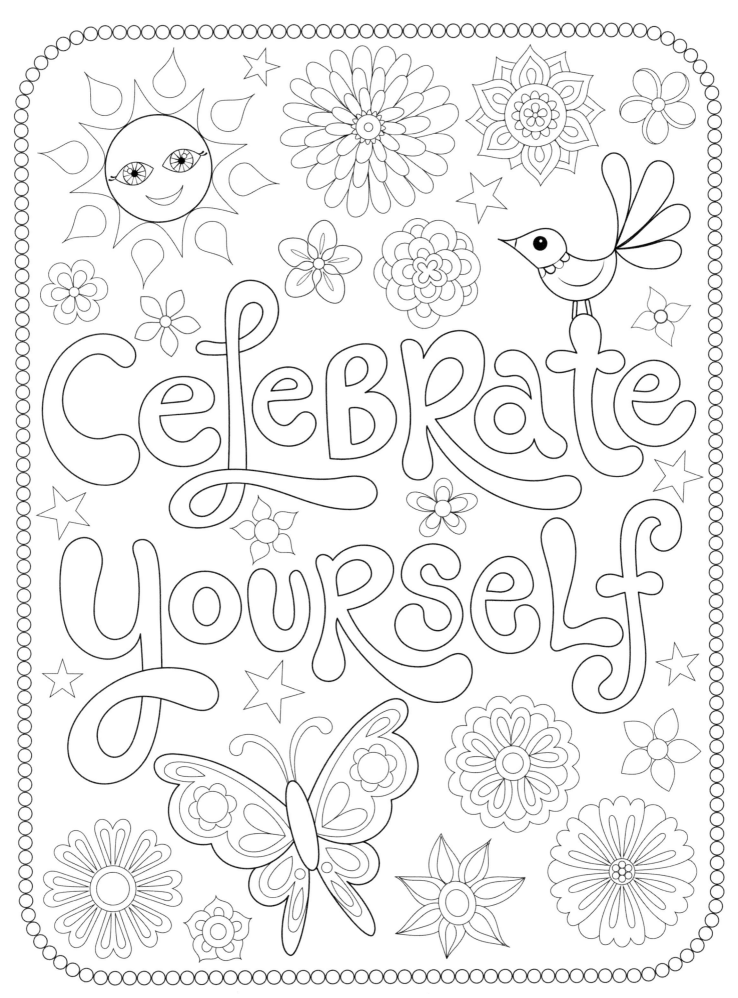

Celebrate Yourself

Why fit in when you were born to stand out?

—Unknown

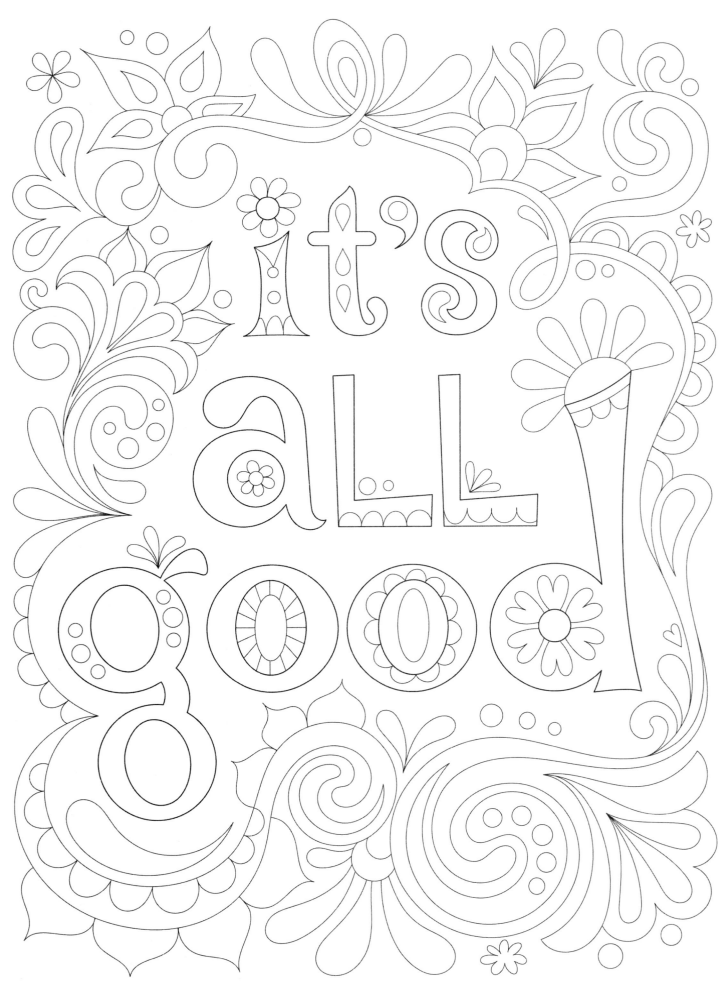

If you have good thoughts, they will shine out of your face like sunbeams, and you will always look lovely.

—Roald Dahl, *The Twits*

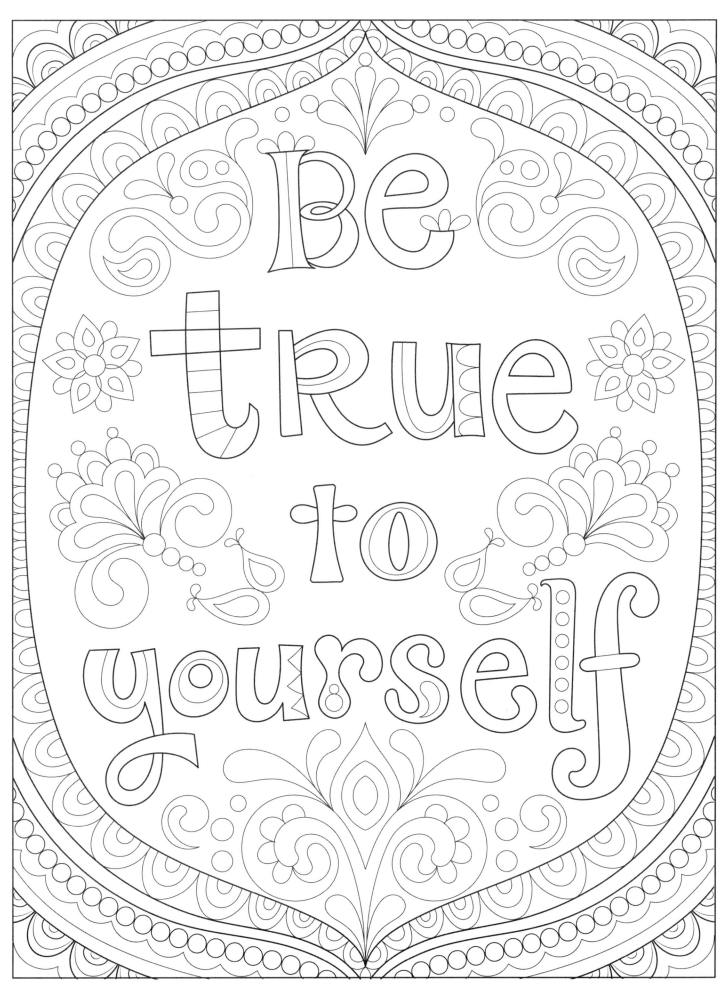

I'm on the right track baby,
I was born to be brave.

—Lady Gaga, *Born This Way*

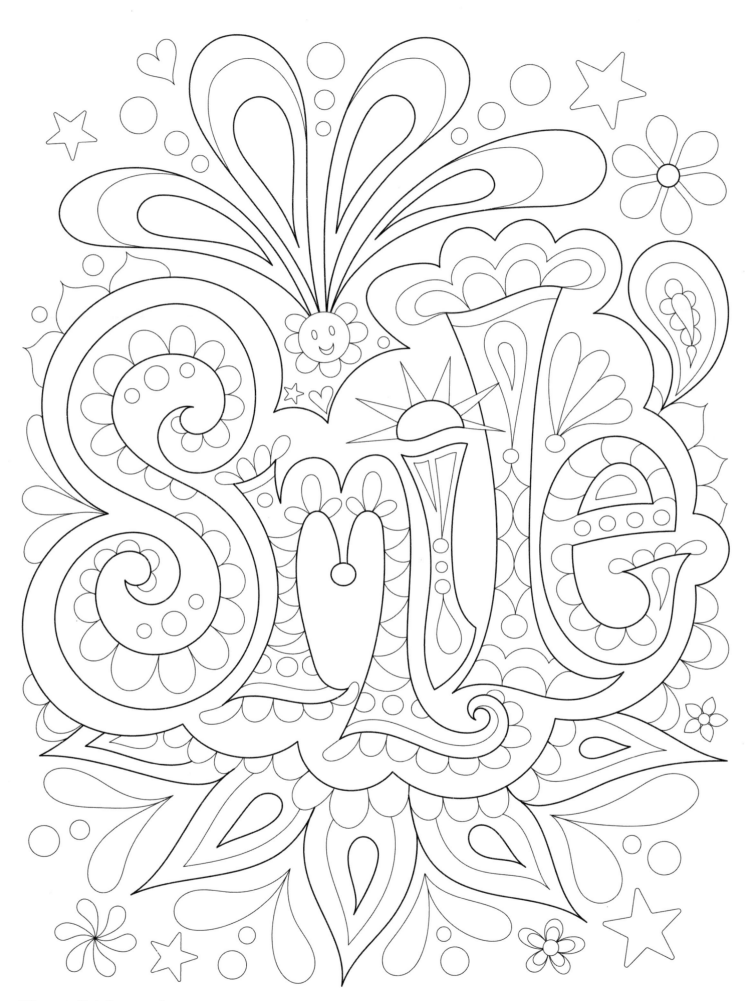

Let your smile change the world,
but don't let the world change your smile.

—Unknown

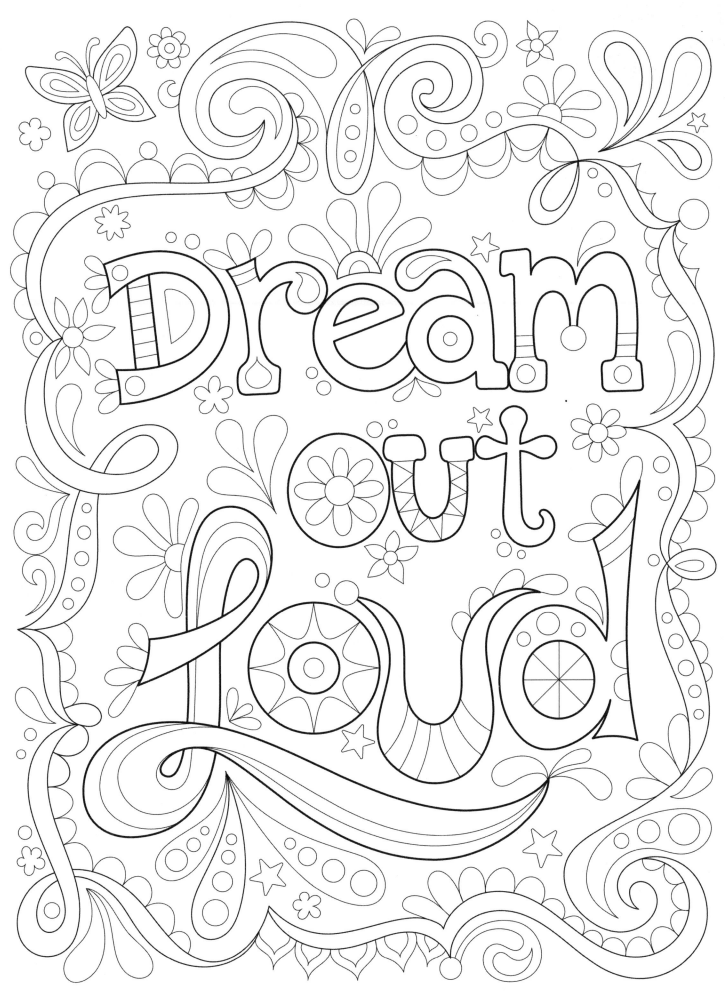

Just don't give up
trying to do what you really want to do.
Where there is love and inspiration,
I don't think you can go wrong.

—Ella Fitzgerald

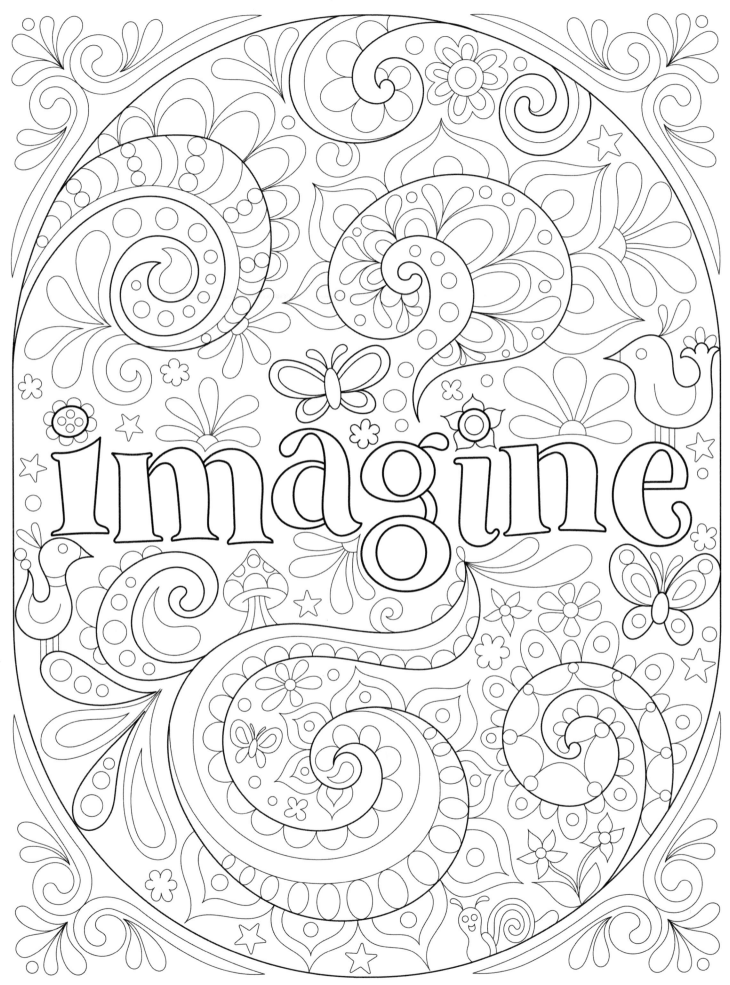

Logic will get you from A to B.
Imagination will take you everywhere.

—Unknown

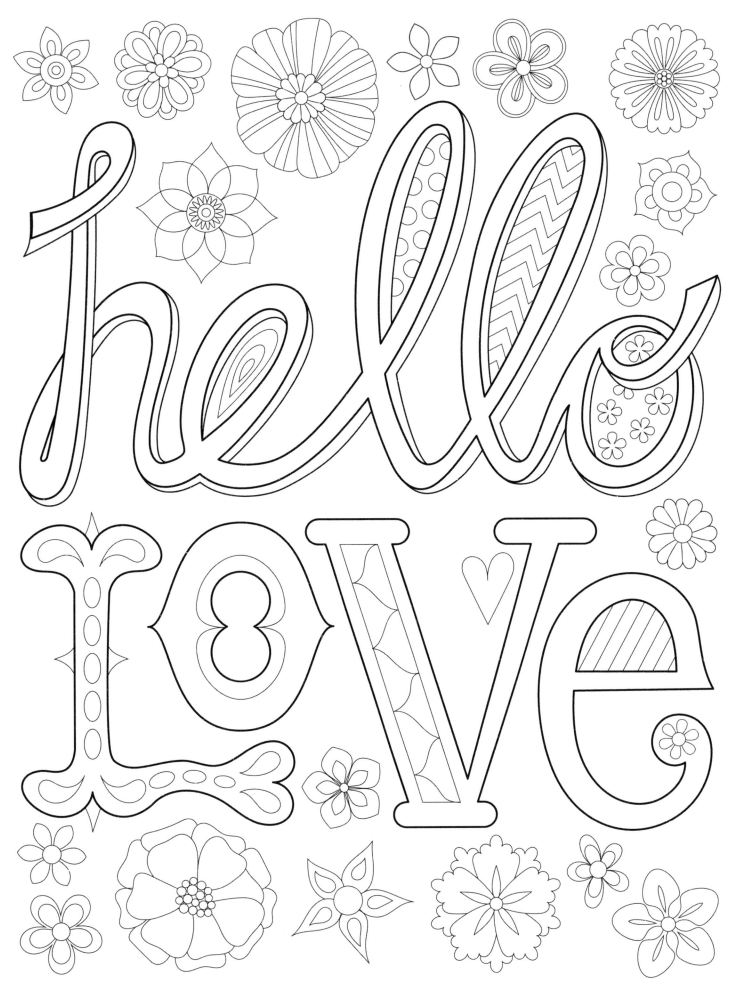

When I see your face
There's not a thing that I would change
'Cause you're amazing
Just the way you are

—Bruno Mars, *Just the Way You Are*

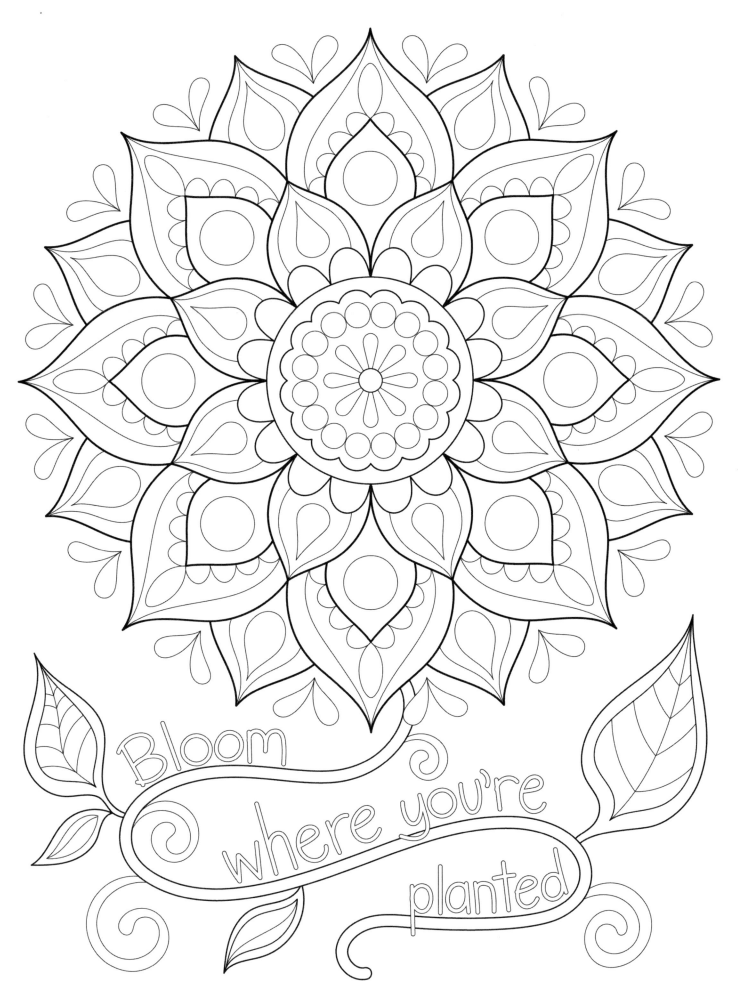

Bloom where you're planted

I can't think of any better representation of beauty
than someone who is unafraid to be herself.

—Emma Stone

If you are not willing to look stupid,
nothing great is ever going to happen to you.

—Unknown